EROTICA

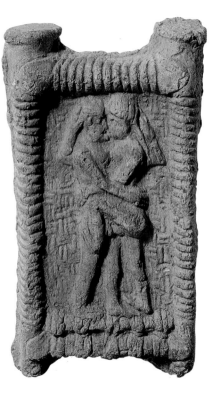

THE BRITISH MUSEUM

LITTLE BOOK OF
EROTICA

INTRODUCTION

The term 'erotica' is usually employed as a catch-all expression for any written or visual material which contains overtly sexual elements, though strictly it should be confined to that which is specifically intended to stimulate sexual feeling. We define erotic art in terms of our own traditions and taboos, and it still comes as a surprise to many modern Western viewers to discover that not all sexual imagery in art was designed merely to titillate.

In many cultures, past and present, the creation of the world and all life has been explained and envisaged in sexual terms, and the union of male and female has been seen as the paradigm of the balance of opposing yet complementary forces which can be perceived throughout nature. The health and fertility of plants and animals are essential to the survival of human communities, and we do not have far to look even today to see the devastation which is wrought when drought or warfare destroys herding and agriculture. Reproduction in humans and animals depends on sexual activity, and the representation of the latter may become a visual shorthand to evoke, and thus encourage, fertility. In some cultures the symbolic depiction of the erect male sexual organ alone was a good-luck charm, because it embodied the idea of sexual competence and therefore of fertility, increase and abundance.

Such concepts are far removed from the naive response of many modern Westerners to erotic or sexual elements in art. The anxiety and embarrassment which are common reactions stand in the way of fuller understanding. Erotica *sensu stricto*, pictures or objects designed to be sexually stimulating, are not only perfectly valid in their own right, but express just one aspect of a wide and universally important subject.

When trying to comprehend human societies other than our own, it is essential to set aside our personal preconceptions and to study the artefacts of those times and places in their own context. Though actual sexual conduct has almost universally been surrounded by strict rules and customs, these have varied widely. Practices regarded as 'unnatural' or objectionable at some times and places have been 'normal' in others. Familiarity with the complex and manifold role of sexual imagery in different societies is indispensable in achieving a desirable objectivity, and it is therefore important that such material is available for study and is assessed alongside other facets of life.

The objects illustrated here express the variety of impulses which have led artists to create erotica, and the differing ways in which other human beings have perceived them: they do much to illuminate the expectations and limitations peculiar to our own society.

CALCITE CARVING OF LOVERS
FROM THE JUDAEAN DESERT, *c.*11,000 BC

This famous statuette, known as the Ain Sakhri figurine, is unique, so it is difficult to date it closely. If the widely accepted date of around 11,000 BC is correct, it may be claimed as the oldest known representation clearly indicating human coitus. We cannot say whether the statuette was purely erotic or whether it had deeper symbolic and religious meanings, but from what is known of Stone Age art, the latter explanation is far more likely.

What is indisputable is that this stylised sculpture, only 10.4 cm high, is an accomplished and sophisticated work of art. Seen from the sides, it depicts a couple tightly locked together, the female sitting in the male's lap with her legs twined around his waist. If either figure is viewed from the back, however, a clear phallic form is revealed. Using very subtle shaping of a natural pebble, the Stone Age sculptor has produced a remarkably evocative image of sexuality.

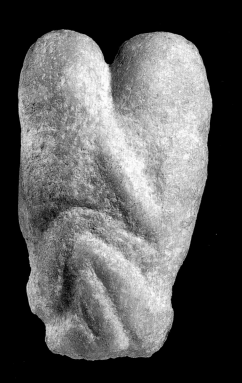

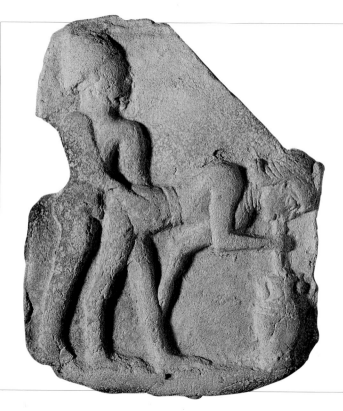

TERRACOTTA PLAQUE

BABYLONIAN, *c*.1800 BC

The scene in low relief on a slightly damaged plaque shows a standing woman who leans forward and drinks from a vessel placed on the ground before her, using a tube or straw. The man approaches her from behind and holds her hips; he wears only a conical hat, while she appears to wear a belt and perhaps necklaces or a choker around her neck. The drink may well have been beer: contemporary written sources include erotic poems indicating a specific connection between the consumption of alcohol and sexual activity. The interpretation of such scenes is unclear, however; it is not known whether the figures represent deities, a priestess and a worshipper enacting a ritual sexual encounter, or ordinary human beings.

Drawing on limestone

Egyptian, New Kingdom, c.1200 BC

Ancient Egyptian drawings made on fragments of stone or pottery range from humorous cartoons and doodles to preliminary sketches for the formal paintings and reliefs seen in tombs. Many are of outstanding artistic quality.

A scene like that shown here was almost certainly made for the personal amusement of the artist, probably one of the workmen who decorated the royal tombs in the Valley of the Kings. There is no reason to suppose that the drawing has any religious or mythological significance, and it may therefore be classed as true erotic art. The standing position, with the male behind his partner, is a common pose in informal ancient Egyptian drawings, and was also favoured in Classical Greek vase-painting. It is difficult to say whether its popularity in art indicates a preference for it in everyday life: the fact that it can be drawn without any complex perspective may have been sufficient reason for its appeal to artists.

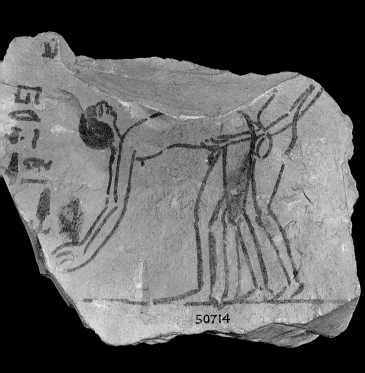

In this detail from a funerary papyrus from Thebes belonging to a priestess of Amun called Tameniu, painted with religious and mythological subjects, the sky-goddess Nut arches over the god Geb, who personifies the earth. Nut and Geb, the offspring of Shu and Tefnut, were themselves the parents of the deities Osiris, Isis, Seth and Nepthys. Shu, the air, separated Nut and Geb, so that the former became the vault of the heavens. Here the earth god is seen falling from his partner's embrace. Nut's connection with the symbolism of resurrection as well as her part in a basic creation myth meant that her image was appropriate in funerary contexts, and her slender, overarching body may be seen depicted in tombs and within the lids of sarcophagi.

The colour green was associated with life,

egetation and fertility and was therefore suitable for Geb, epresenting the earth itself. The naive modern response to a ainting such as this is to focus only on the god's enormous rect phallus and to see the scene as primarily sexual. In fact, ne sexual element is only a small part of a highly complex ystem of religious belief.

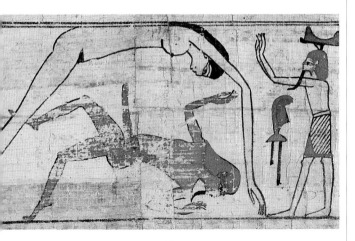

The *kylix* was a shallow cup with a pedestal base and handles: it was an appropriate vessel for drinking wine. Painted decoration could be applied to the exterior sides of the cup and also to the interior, where it would be revealed as the contents were consumed.

Erotic scenes were not uncommon on Greek painted pottery, and may have been particularly appropriate in the context of the predominantly masculine drinking-parties at which cups such as these were used. The ancient Greek *symposion* might range from an intellectual discussion-group to a no-holds-barred orgy, but in any case respectable women were excluded. The only females present would be *hetairai*, namely courtesans, and entertainers such as dancers and musicians, who performed scantily clad or completely naked. The blatant eroticism of vase-paintings such as these is tempered by the the fluency and elegance of the drawing.

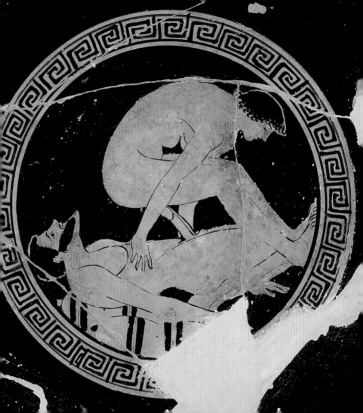

Glazed composition amulet
Egyptian, Ptolemaic Period,
4th-3rd century BC

Glazed composition, also known as Egyptian faience, was employed from very early times for the manufacture of a wide range of objects, including small amulets. Often in the form of deities or animals associated with gods, these would be carried or worn to bring good luck to their owners.

The amulets of late Pharaonic and Ptolemaic times include many which depict sexual imagery, often of an apparently humorous kind. Yet although ithyphallic gods such as the Egyptian Min, the Greek god Pan and the Roman Priapus all represented power and protection against misfortune and evil, and the phallus alone could carry the same symbolism, the precise significance of grotesque images such as the one shown here is by no means fully understood. The figurine, only some 4 cm high, has a suspension loop at the back and was thus certainly designed to be worn as a charm.

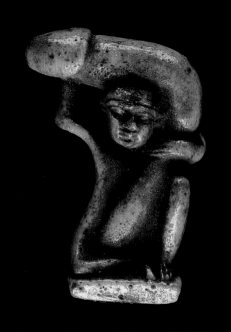

Silver wine-cup with homoerotic scenes
(The Warren Cup)
Roman, 1st century BC–1st century AD

Graeco-Roman attitudes towards homosexuality were tolerant and pragmatic compared with those of more recent times, but the Classical perception of sexuality was unlike ours. Sexual relationships were about power and status as well as simple desire, and representations on Greek painted vases of men and youths often emphasise the ritual exchange of gifts and the role of the older men as social patrons and mentors of the younger.

Elegant silver wine-cups, gracefully decorated with foliate patterns or mythological scenes, were used at dinner parties of wealthy Romans. This example, originally designed with two handles, features two homoerotic scenes – a man and a youth making love on one side, and a youth and a boy on the other. The subject may have had a special meaning for the owner, but none of his guests would have disapproved.

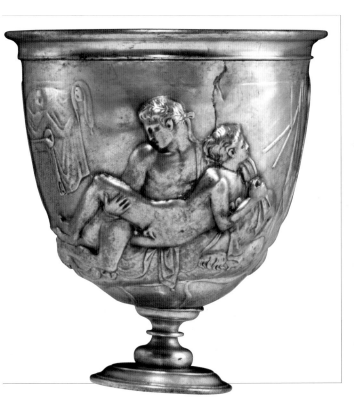

MARBLE RELIEF OF LEDA AND THE SWAN
ROMAN, 1st CENTURY AD

Leda, wife of Tyndareus, was seduced by the god Zeus in the form of a great swan, and he fathered upon her Helen and the divine twins Castor and Pollux. In some versions of the myth they were hatched from eggs. Zeus often chose to take the form of an animal when consorting with mortal women, but the story of Leda was the one most commonly depicted in Classical art. It went on to become a favoured subject in the Renaissance and later periods, perhaps because it was perceived as an acceptably mild and unreal vision of eroticism. Leonardo da Vinci, Michelangelo and Raphael amongst others created versions of the Leda myth. Yet the idea of a woman sexually overwhelmed by an enormous bird is far from being a gentle fantasy: the Zeus-swan in this relief seizes the submissive Leda with his powerful beak and claws, and conveys ferocious passion rather than dream-like romance.

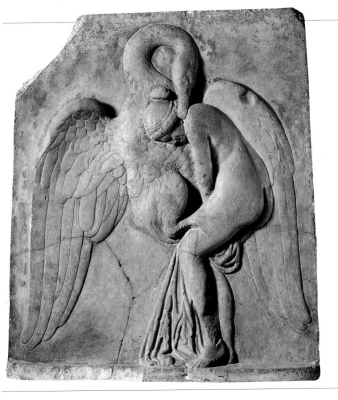

POTTERY LAMP DEPICTING LOVERS ON A BED

ROMAN, 1ST CENTURY AD

Mould-made pottery lamps were mass-produced in huge quantities in the Roman world. Using olive oil as fuel, they were an inexpensive and effective form of artificial lighting. The circular upper surface on many forms of lamp w known as the *discus*, and was decorated with a wide range o subjects, some religious or symbolic, others purely ornamenta or depicting scenes of entertainment or everyday life. Erotic subjects sometimes had mythological connotations, but often, as here, they would seem to have been no more than evocations of pleasure and enjoyment. The bird's-eye view of the bed and its occupants is an unusual and rather adventuro one, enabling the artist to show quite clearly a common and domestic position for lovemaking; many of the positions favoured in Roman erotic art are considerably more athletic.

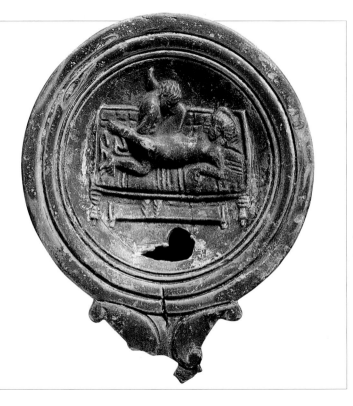

POT WITH PHALLIC DECORATION
ROMANO-BRITISH, 2ND-3RD CENTURY AD

In the Roman world, phallic representations were believed to promote good luck and avert evil. They would not normally have aroused thoughts of sensual enjoyment, and were therefore not erotic in the strict sense; they were simply good-luck charms. The personification of the phallus as a complete independent creature, very often a bird, was common, and there may have been a punning connection with slang terms for the organ in Latin.

The pot shown here was made in Britain, and was found during archaeological excavation of a Roman site in Cambridgeshire. Although an inexpensive everyday utensil, like most Roman pottery it is beautifully designed and made. The decoration in low relief was executed by trailing soft clay onto the surface of the vessel before firing, and the potter has skilfully depicted a procession of alternating phalli and phallus-birds complete with legs and wings.

ANTHROPOMORPHIC POTTERY VESSEL
PERUVIAN, MOCHÉ CULTURE, AD 100-700

The ceramics of the Moché culture of coastal Peru were exceptionally sophisticated in both technique and design. Modelled vessels depict both anthropomorphic and zoomorphic forms, including a wide range of sexual scenes. These are usually taking place within a ritual context and are likely to be closely linked to seasonal concerns with both agricultural fertility and human procreation. This stirrup-spout vessel shows a high-ranking male figure attended by a female, perhaps a concubine. The man's right hand reaches across to the woman's face and hints that an element of coercion may be involved. Since the Moché left no written records, such imagery offers important clues to the nature of relationships between men and women in pre-Columbian times

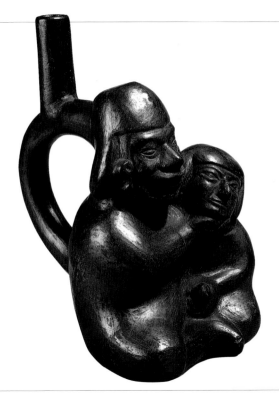

AMOROUS COUPLE (*MITHUNA*)

NORTHERN INDIA, PROBABLY RAJASTAN,
10TH CENTURY AD

These two lovers carved in sandstone are not deities, thoug the relief probably formed part of the intricate sculptural decoration of a Hindu temple. The mystical imagery of the human soul seeking union with the divine was commonly expressed in sexual terms: creation was regarded as a sexual process, and sexuality therefore partook of the divine. This view may have extended to the performance of orgiastic rites as an element of religious observance.

To the modern western viewer, the impact of sculpture suc as this lies not only in its total artistic confidence but in its inne assumptions, its very evident lack of guilt and shame. The lush supple figures, carved with consummate technical mastery, express a delight in human sexuality which was permanently lost to western culture once Graeco-Roman paganism had bee superseded by the Christian Byzantine Empire.

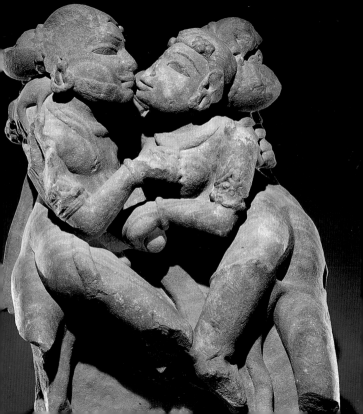

The stele is a territorial marker and bears a Sanskrit inscription recording a grant of land. The sun and moon, shown as a disc and crescent at the top, indicate that the grant was in perpetuity, i.e. that it was to last as long as the celestial bodies endure. The panel near the base depicts the punishment which will befall those who disturb the stele and appropriate the land, namely that their womenfolk will be disgraced by being violated by a bull.

Here, sexual imagery is being used as an aggressive threat or warning rather than as religious symbolism, eroticism or satire. Though curses in the Graeco-Roman world frequently wished extreme physical distress on their subjects, in the Indian tradition a curse of this sexual nature was particularly strong, as an entire family's status and social reputation was and is dependent on the proper conduct of the women.

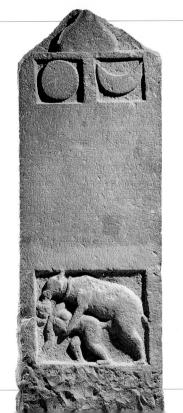

Pewter badge

English, 14th century

Base-metal hat-badges were usually religious devices connected with pilgrimage, an activity of great importance in medieval Europe. Pilgrims who had travelled to particular shrines wore the sign or symbol of that place.

Some lead and pewter badges were wholly secular, however, and included surprisingly explicit sexual subjects. They may have been satirical: depictions of female genitalia, sometimes with arms and legs transforming them into fantasy personifications, might have been an attack upon the false piety of women believed to take part in pilgrimages mainly in pursuit of sexual adventure. Personified phalli also occur, and this example, a phallus-bird with legs and wings, immediately recalls Roman objects made more than a thousand years earlier. Does such an image have some humorous or satirical meaning, or is it conceivable that in the Christian milieu of medieval England it might still have been worn for luck?

MEDAL OF PIETRO ARETINO (1492-1556)

ITALIAN, *c*.1540

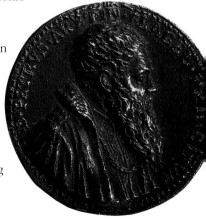

The sixteenth-century Italian writer Pietro Aretino was notorious as the author of a series of explicitly erotic sonnets, published around 1527 to accompany a set of engravings by Marcantonio Raimondi (see p.48).

The obverse of this cast bronze medal is an accomplished conventional portrait of its subject, but the reverse is a grotesque satyr's head built up from numerous phalli. The conceit of creating a human head out of independent pictorial

ements goes back to Classical prototypes: such devices are
sometimes found on Roman engraved gems. A slightly
younger Italian contemporary, Giuseppe Arcimboldo, later
took the idea to extremes with his paintings of heads made
up of vegetables, sea-creatures and other unexpected objects.

As it is not known who commissioned the medal, the
precise intent of the reverse image remains uncertain, but
broadly it must be seen as a
scurrilous reference to
Aretino's skilful satire, his
allegedly libertine way
of life and the sexual
impropriety of some of
his work.

ENGRAVING, *NIGHT*

SEBALD BEHAM (1500-1550)

The use of woodcuts and engravings to illustrate books
and popular broadsheets, both sacred and profane,
flourished in sixteenth-century southern Germany. Nuremberg
was one of the centres of this branch of art, and the brothers
Sebald and Barthel Beham were two of its notable
practitioners. There was apparently an avid market for erotic
prints, and the brothers collaborated on such material as well
as biblical, mythological and historical subjects.

The Italian Renaissance, with its awareness of Classical
antiquity, increasingly influenced German art in the sixteenth
century, and its effect is clearly to be seen in the engraving
illustrated here. The unselfconscious nudity of the woman on
the bed evokes the imagery of Classical paganism, and lest
there should be any doubt about her sexual invitation, the
Latin quotation on the bed-head is taken from Ovid's *Amores*:
'Night and love and wine do not counsel moderation.'

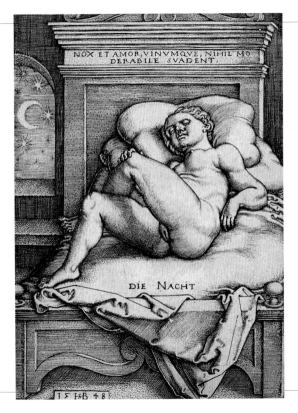

NOX ET AMOR, VINVMQVE, NIHIL MO
DERABILE SVADENT.

DIE NACHT

1 5 HSB 4 8

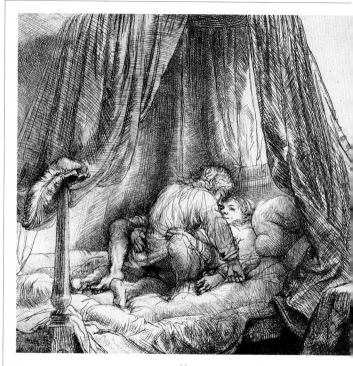

Etching, *The Bed*

Rembrandt van Rijn (1606-1669)

The greatness of the artist and the subdued, cosily domestic impression conveyed by the scene have made his etching by Rembrandt more acceptable for reproduction than the majority of explicit representations of lovemaking. Both of the lovers are almost covered in enveloping garments – only faces, hands and legs are bare – and the woman's face reveals contentment rather than passion. There are oddities in the drawing which suggest that the artist was more concerned with atmosphere and suggestion than with technical accuracy. The woman's left arm is depicted twice, and her partner's kneeling pose does not align very convincingly with her completely supine position. The overall effect, however, is at least as erotic as many very detailed and precise portrayals of lovemaking. The huddled figures in the comfortable context of the huge bed suggest emotional as well as physical intimacy.

Porcelain birds in *Famille verte* enamels

Chinese, Qing dynasty, reign of the Emperor Kangxi, AD 1662-1722

These colourful and decorative porcelain figures were manufactured in South China, at Jingdezhen in Jiangxi province. The phoenixes are depicted with a rock and a tree peony. Beneath and in front of each bird is a hollow area closed by a movable flap, which when raised reveals a tiny nude couple, locked in a sexual embrace.

Many plants and flowers, birds and animals, both natural and mythical, and features of the landscape and the heavens had symbolic meanings in Chinese art, but such nuances would have meant nothing to the European buyers for whom ornaments such as these were intended. The taste for erotic scenes coyly concealed in an object of use or ornament was perhaps most typical of the nineteenth century in Europe, but it was clearly already being catered for in earlier exotic imports such as these.

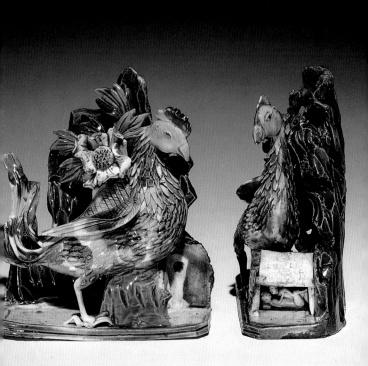

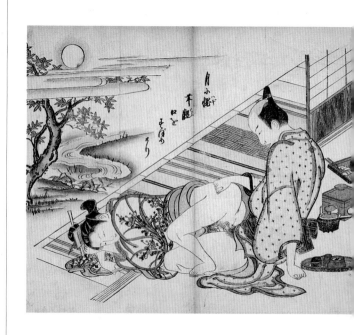

月小傾
弁慶
口と
そばか
り

HAND-COLOURED WOODBLOCK PRINT

LOVERS ON A VERANDAH

OKUMURA MASANOBU (1686-1764)

Japanese woodblock prints, whose bold and elegant graphic qualities were to exercise a marked influence on Western fine and applied arts towards the end of the nineteenth century, included a class known as *Shunga* ('spring pictures') which celebrate sensual enjoyment with complete candour.

This example, dated to about 1740, is one of a series entitled 'Models for the bedchamber'. The setting shown is probably a luxurious house of pleasure, and the participants are therefore courtesan and client. Trays of refreshments are close at hand, and the season of the year is indicated by the vivid foliage of the maple tree and echoed in the decorative pattern of the woman's robe. The moon, shining above the maple, was considered to be at its most beautiful in the autumn. Such details build up an ambience of pleasure which goes beyond the sexual activity forming the focus of the picture.

COLOUR WOODBLOCK PRINT

MAN MAKING LOVE TO SIX WOMEN

KATSUKAWA SHUNCHŌ (FL.1770s-1790s)

This large print of double *ōban* format (52.7 x 39.2 cm) belongs to a series entitled 'Twelve tastes in the classification of passion'. It was originally folded up and had probably been elegantly wrapped with a colour-printed envelope for presentation as a gift; it dates to around 1785.

The exaggerated treatment of the genitals in Japanese erotic prints may be an echo of an ancient tradition of phallic symbolism akin to that of the Roman world, or it may simply be a graphic device to focus on the centrality of the sexual content of the scenes. It is balanced by equally precise and intricate renderings of the richly ornamented textiles and other details which convey the overall impression of wealth, leisure and appreciation of the good things of life. There could be elements of parody in this scene: the Seven Gods of Good Luck comprised six male deities and one female.

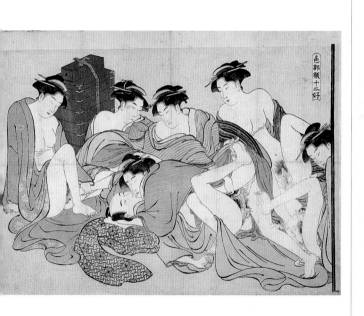

色郎頻十二好

PEN AND WASH DRAWING

AFTER AN ENGRAVING BY RAIMONDI

FRIEDRICH WALDECK (1786-1865)

The erotic engravings published by Marcantonio Raimondi in the 1520s were based on designs by Giulio Romano, and became as famous as the sonnets by Pietro Aretino which they inspired. They depicted a variety of positions for lovemaking, some of them demandingly athletic, and include many visual references to Classical antiquity.

Only a few small and bowdlerised fragments of the original sixteenth-century engravings survive, but many copies had been made over the years, and the drawing reproduced here is from a full series drawn by Waldeck in the early nineteenth century. The style is a complex amalgam, the result of a neo-Classical artist interpreting Renaissance work which had itself been inspired by antiquity. Waldeck's drawings may lack the vigour of the lost originals, but they would seem to convey something of their spirit and quality.

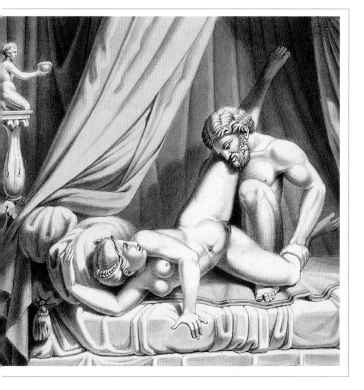

TERRACOTTA STATUETTE, PAN AND A GOAT
JOSEPH NOLLEKENS (1737-1823)

The eighteenth century saw the rediscovery and excavation of the ancient cities of Pompeii and Herculaneum, and the finds provided a new impetus to the developing fascination with the art and archaeology of Classical antiquity at this time of intellectual curiosity. The relaxed attitude to sexual and phallic imagery in the early Roman Empire, revealed in the publication of illustrated volumes of antiquities from the Vesuvian cities, made a strong impression on scholars.

Nollekens was a distinguished sculptor who created portraits of the great and the good. Here he has modelled from memory a small copy of the notorious Roman marble statuette from Herculaneum showing the god Pan copulating with a goat. The imagery would have been commonplace to first-century Roman, but probably appeared startling to an eighteenth-century Englishman. The Nollekens terracotta is a

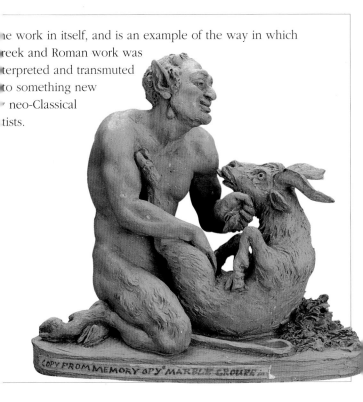

...e work in itself, and is an example of the way in which ...reek and Roman work was ...terpreted and transmuted ...to something new ... neo-Classical ...tists.

COPY FROM MEMORY OF MARBLE GROUPE

ETCHING, *THE HAREM*

THOMAS ROWLANDSON (1756-1827)

Rowlandson was one of the most talented English caricaturists and social satirists of the late eighteenth and early nineteenth century. His work formed a cynical and entertaining commentary on the manners of his time at all levels of society, and included a substantial number of sexual subjects depicted with utter candour.

The Middle East exerted a romantic fascination on northern Europeans at this period. Serious scholars travelled there and were impressed and captivated by the culture of the region, but the less well-informed imagined that 'the Orient' was a world of luxurious and untrammelled licentiousness. Written pornography of the nineteenth century is full of heated fantasies of harems and lustful sultans. Though this etching could easily pass for an illustration to such a story, it possesses the irresistible humour characteristic of Rowlandson's work. The lone male can scarcely hope to

enjoy more than a small sample of the endless array of feminine charms displayed before him.

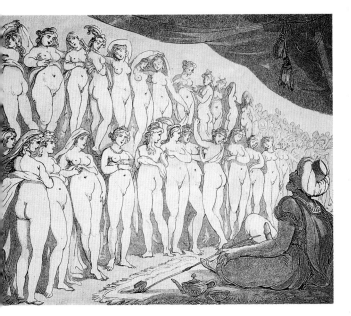

YAMANTAKA AND HIS CONSORT
SINO-TIBETAN, AD 1811

This large and spectacular gilded bronze depicts Yamantaka, the 'Destroyer of Death', in union with his consort. Yamantaka is a terrifying manifestation of Manjushri, the Bodhisattva of knowledge and wisdom. Bodhisattvas are beings which partake of the nature of the Buddha, and act as saviours and intermediaries for human beings. The gestures of the numerous hands and the attributes which they hold have specific meanings in the complex iconography of Tantric Buddhism. The representation of deities in a sexual embrace was a common device for symbolising the truths of esoteric Buddhism: sexuality was a power integral to all beings, and the union of male and female released its full potential.

The statuette, a temple votive, bears an inscription in Chinese characters on the back which records the name of the donor and the date of dedication, AD 1811, in the reign of the Chinese Emperor Jiaqing (AD 1796-1820).

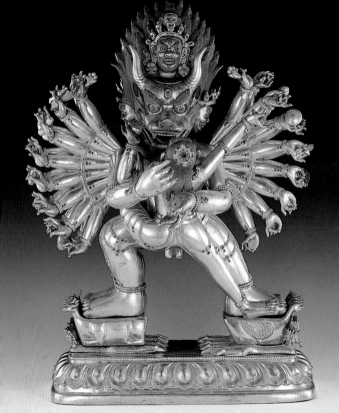

POCKET-WATCH WITH EROTIC SCENE

SWISS, EARLY 19TH CENTURY

When closed, the applied low-relief decoration in brass below the small dial of this watch depicts a woodland scene with a huntsman and a stag, improbably flanking a pair of enamelled doors. Behind the doors we find a minuscule pair of enamelled figures, the woman leaning against a tree and the man behind her. The male is articulated and moves rhythmically, if somewhat frantically, driven by the watch mechanism (his left arm is now lost). Miniature automata as components of pocket-watches were popular in the early nineteenth century, but were often in the form of innocent scenes such as blacksmiths striking anvils. However, there was also a taste for watches with enamelled pornographic scenes, and inevitably the two ideas were sometimes combined.

Erotic decoration on European personal possessions of the nineteenth century is inclined to have a furtive air, reflecting

the social attitudes of the
time. An object such as
this one cannot claim any
great artistic merit, but it is
both ingenious and
amusing.

The small lidded bowl decorated in *famille rose* enamels was made at Jingdezhen, in Jiangxi province, South China. The series of figures painted on both bowl and cover depict naked couples approaching each other or actually making love in a variety of poses.

Overtly erotic decoration of this kind was not intended for the home market but for export to the West, and watercolour paintings in a similar style were also made for the same purpose. Though erotic themes and ideas were present in Chinese art, they were generally expressed through subtle symbolism rather than direct representation.

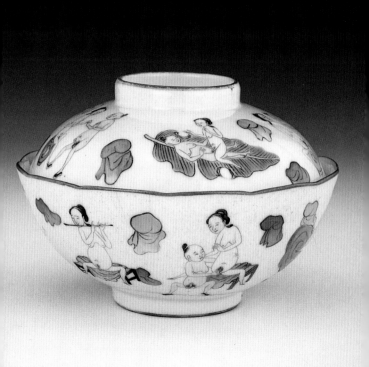

ACCESSION NUMBERS OF OBJECTS ILLUSTRATED

cover GR D.213
frontispiece WA 115719

page

First published in 1997 by The British Museum Press
A division of The British Museum Company Ltd
38 Russell Square, London WC1B 3QQ

Paperback edition 2004
Reprinted 2005, 2006, 2008, 2009

A catalogue record for this book is available from the British Library

ISBN 978-0-7141-5026-0

Text by Catherine Johns
The author gratefully acknowledges the advice and assistance of Museum
colleagues in the preparation of this book
Photography by the British Museum Photographic Service
Designed by Butterworth Design
Cover design by Harry Green

Typeset in Garamond
Printed in China
by Hing Yip Printing Ltd

Cover illustration: Terracotta vessel in the form of a couple on a couch.
Graeco-Roman, 2nd–1st century BC.

Frontispiece: Terracotta of a bed with lovers. Babylonian, c.1800 BC.